EL CAPITAN

YOSEMITE ICON

YOSEMITE CONSERVANCY

YOSEMITE NATIONAL PARK

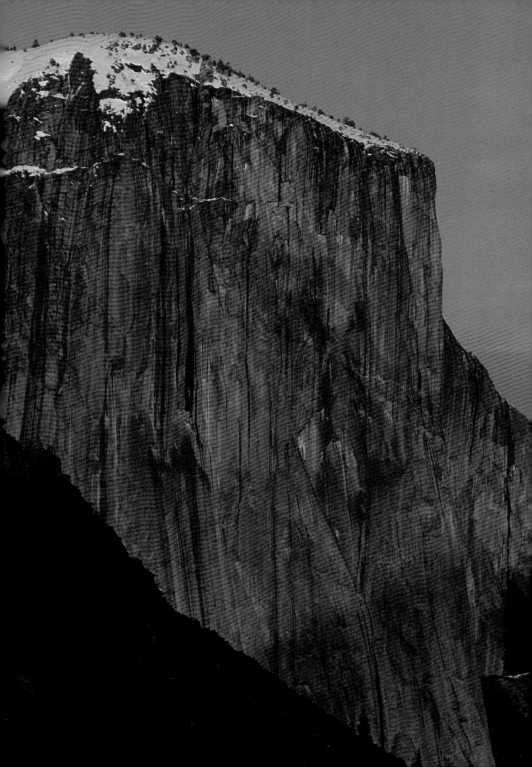

Welcome! You're about to meet an enormous rock, commonly called El Capitan. But first, meet its home: Yosemite National Park, one of the world's most popular outdoor destinations.

Yosemite is in California's Sierra Nevada range, and more than 90 percent of the park is federally designated wilderness. Yosemite covers 11,200 feet (3,414 m) of elevation and an area of 1,187 square miles (3,074 km²).

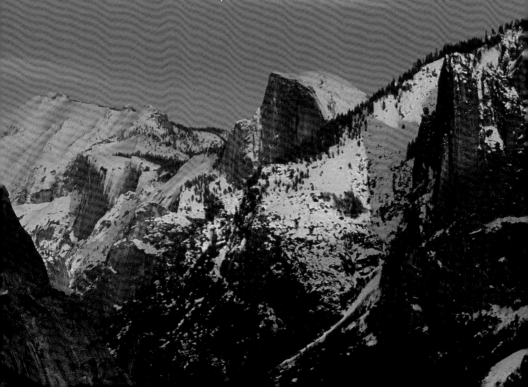

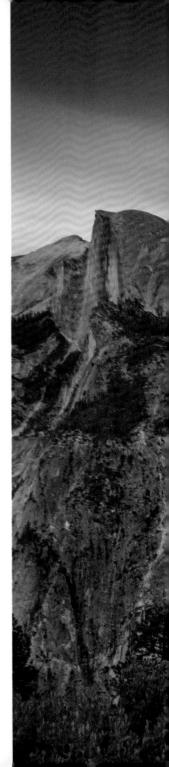

Okay, Yosemite is big. But what makes it so special?

Over one thousand kinds of plants and more than four hundred vertebrate species live in Yosemite. Yosemite even has one of the greatest diversities of bees in the world! Delicate mariposa lilies and thumb-length Yosemite toads share the park with 150-pound (68 kg) mountain lions and 200-foot-tall (61 m) giant sequoia trees. Endangered foxes, frogs, fishers, birds, and bighorn sheep find a home here. So do rare plants, like three-bracted onions and slender-stemmed monkeyflowers.

Then there's the terrain. Yosemite is a mosaic of meadows, forests, waterfalls, rocky summits, and river canyons. And all over the park, you'll find speckled, sparkling granite.

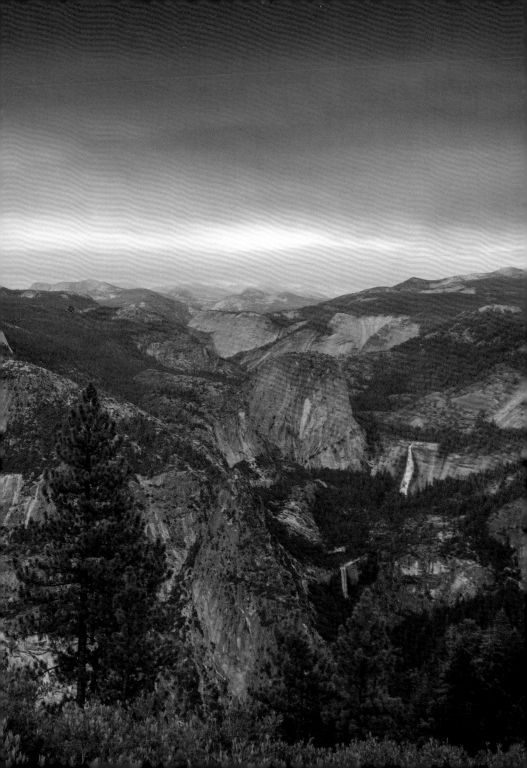

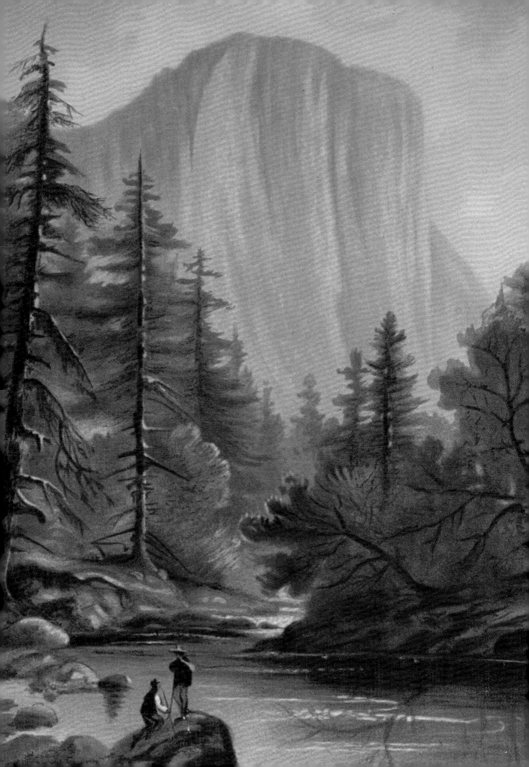

Yosemite's geological record spans ages—and is still unfolding. Here's the quick version: 100 million years ago, molten rock solidified deep underground. Over eons, erosion exposed the newly formed granite on Earth's surface, and rivers and ice helped shape the landscape. Glaciers smoothed cliffs and polished domes, dropping boulders (called *erratics*) as they retreated. Even today, the rock is still changing; most of the differences are too small or slow to see, but occasionally granite sheets and boulders slide off Yosemite's steep walls.

This extraordinary place has a long and complex human history, too. In the 1860s, photographs, paintings, and reports of Yosemite's landscape helped inspire the United States' first public-lands legislation. Yosemite is often seen as the birthplace of the national park idea. But the human story goes back much further.

Since time immemorial, Yosemite has been the ancestral home of the people now known as the Bishop Paiute Tribe, Bridgeport Indian Colony, Mono Lake Kootzaduka'a Tribe, North Fork Rancheria of Mono Indians of California, Picayune Rancheria of Chukchansi Indians, Southern Sierra Miwuk Nation, and Tuolumne Band of Me-Wuk Indians. The people retain deep cultural, spiritual, and ecological ties to the land. Please remember that this place is still home to the Traditionally Associated Tribes, who ask that this sacred landscape be treated with the utmost care and respect.

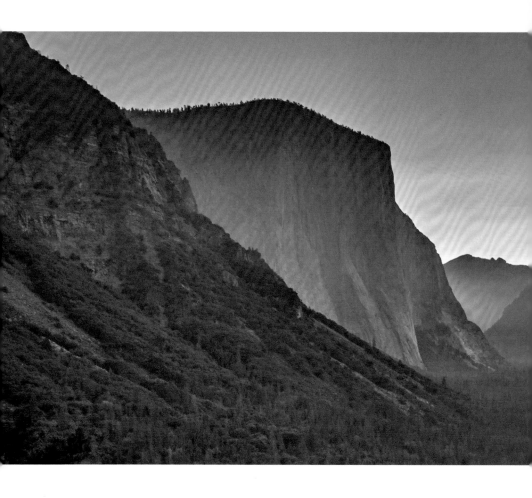

There's the answer to our question: Yosemite is special because it holds a unique place in cultural history. It's home to incredible biodiversity and fascinating geology. It's beautiful. And it's unlike anywhere else in the world.

Nothing embodies that individuality quite like the icons—the features that, in a place teeming with natural wonders, steal your attention and won't let go.

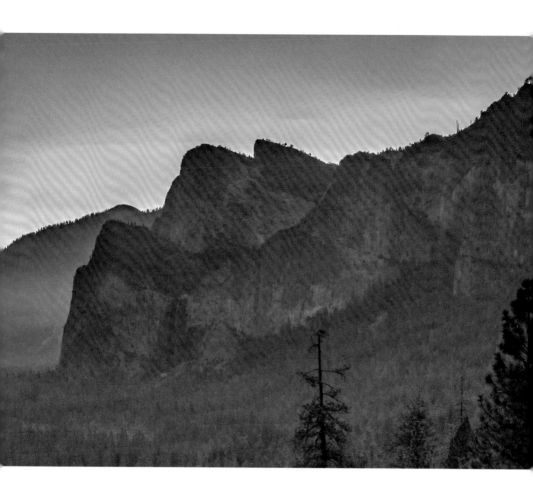

Among Yosemite's icons, El Capitan stands out. Literally. It's an immense granite pillar protruding from the north side of Yosemite Valley. El Capitan is a home for cliff-dwelling plants and wildlife. It's a world-renowned rock-climbing destination. And it's a window into a primeval magma chamber. That's an impressive resume for a chunk of stone. Want to know more? Read on!

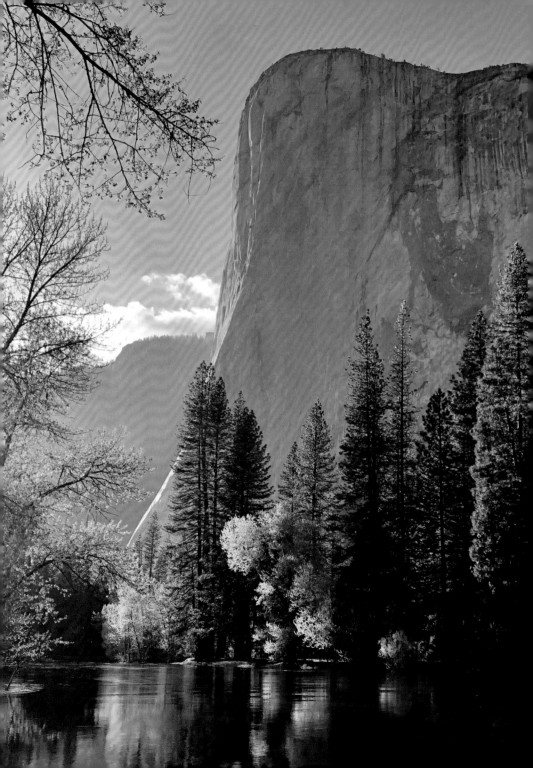

Natural History

El Capitan towers over western Yosemite Valley. This icon is called a "big wall" for good reason. Taking up a giant section of the Valley's north wall, El Capitan juts out like a ship, with two cliff faces meeting in the middle to form a prow, called The Nose.

M any of Yosemite's other famous rock formations awe us with their spindly spires or glossy domes, but El Capitan stuns with its sheer bulk. It rises 3,593 feet (1,095 m) from base to summit, two and a half times the height of the Empire State Building. It peaks at an elevation of 7,569 feet (2,307 m), and, east to west, spans about 1.5 miles (2.4 km).

Within and around that colossal frame, you'll find clues to El Capitan's past and present—if you know where to look.

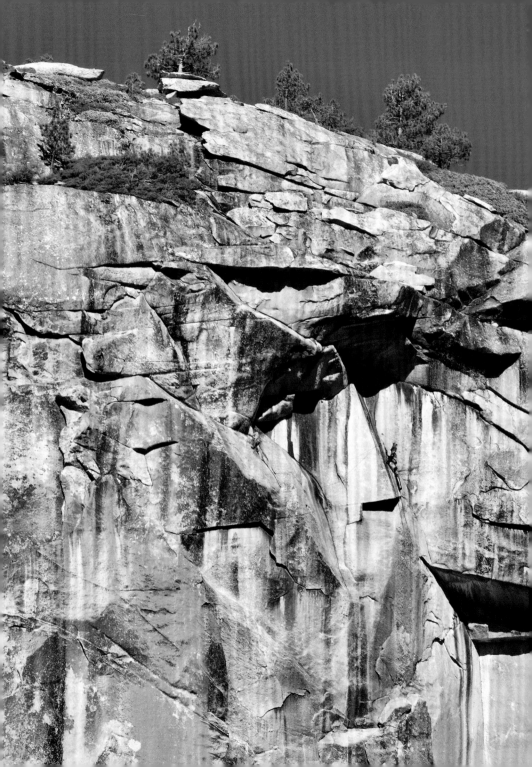

THE BACKSTORY

Like all Yosemite granite, El Capitan got its start as subsurface molten rock. That magma cooled into masses called *plutons*, and then, as the Sierra Nevada uplifted and the overlying material wore away, the rock was exposed.

Today, if you look closely, you can see the icon's history right there on the cliffs.

Start with the colors. Much of the rock is a light, sandy hue, but you'll see darker shades, too. Why? Those are different granites with varying amounts of certain minerals. The oldest materials in the icon are made of El Capitan Granite and Taft Granite. They dominate the cliffs and can be identified because they contain lots of light-colored quartz and feldspar. The younger diorite of North America, rich in dark hornblende, is visible as inky patches on the walls.

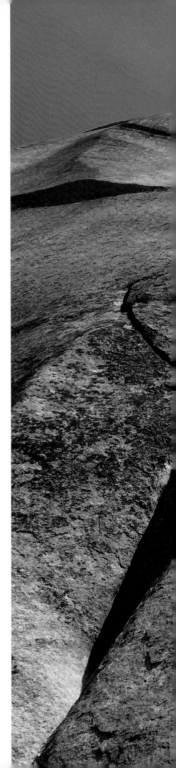

Another hint about El Capitan's story lies in its polished texture. Over millions of years, the rock slowly expanded, free from underground pressure. Glaciers then scraped and sculpted the Valley's floor and walls, peeling off El Capitan's outer layers as water and ice polished the granite.

El Capitan also offers clues to more recent geological history. Since the last glaciers melted out of the Valley, about fifteen thousand years ago, rockfalls have been the prime sculptors of Yosemite's cliffs. For evidence, look no farther than the rubble around El Capitan's base. That's *talus*, debris from granite slabs that have slid down the walls. Among the rubble from recent rockfalls, there are car-sized boulders from a four-thousand-year-old avalanche. (Rocks from newer events will be bare; ones that fell a long time ago may be covered in moss or lichen.)

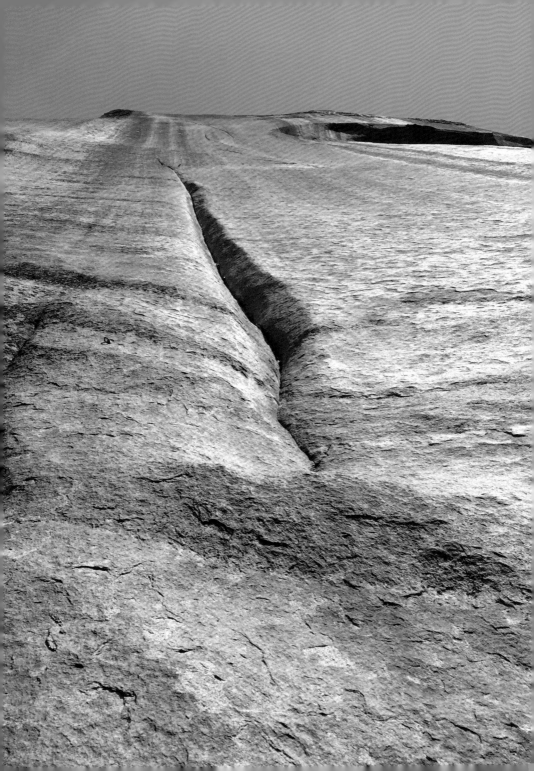

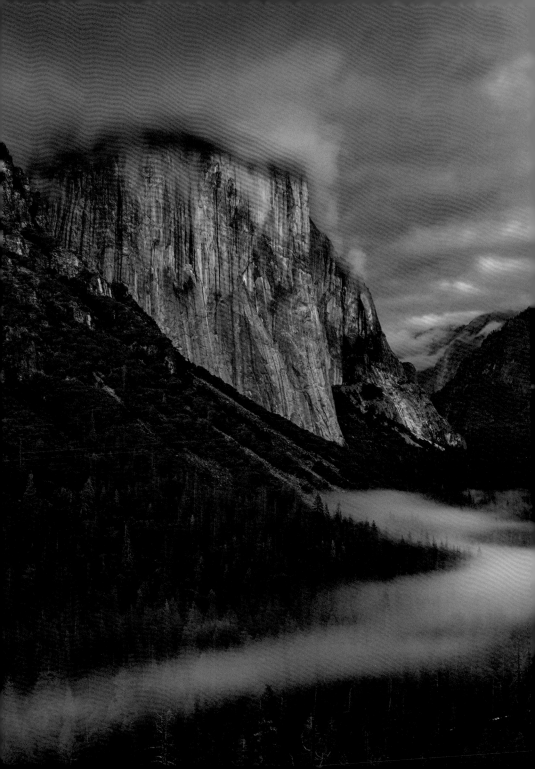

THE SURROUNDINGS

A low ridge stretches across the Valley floor from El Capitan on the north side to Cathedral Rocks on the south. That's a sign that a glacier was once here. Slow-flowing ice carried rock debris westward through the Valley, and then when the glacier melted thousands of years ago, it left the material in a heap, called a *moraine*.

Today, the El Capitan moraine is mostly buried and looks like a gentle hill topped with boulders. Back when it was formed, though, the moraine was high enough to dam the melting ice into a shallow lake. The sand and silt that built up underwater created the relatively level Valley floor you see today.

You get the idea—between the talus and moraine, there's a lot of rocky debris around El Capitan. But there are plenty of other impressive, intact formations nearby, too. On the icon's east side, Eagle Peak, the highest of the Three Brothers granite formation, rises 215 feet (66 m) above El Capitan's summit. Beyond the Brothers, Yosemite Falls rages with spring snowmelt and whispers through hot summers. Across from El Capitan, Bridalveil Fall dances down the Valley's south wall, catching rainbows in its spray.

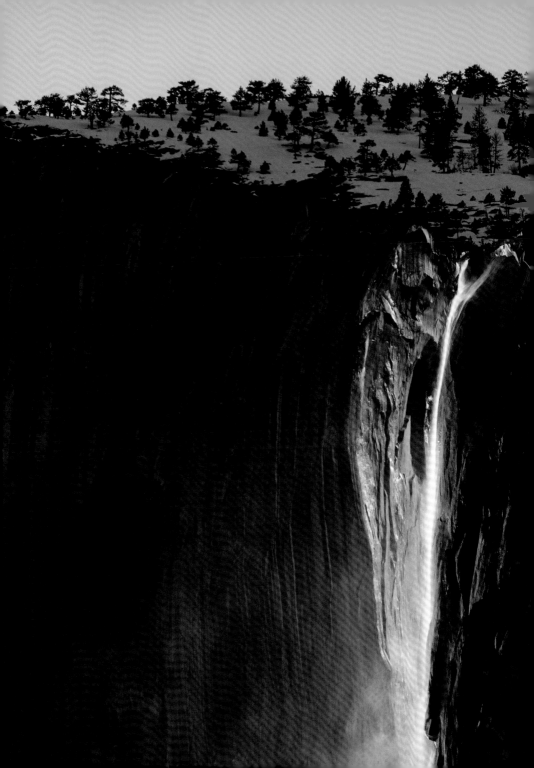

Speaking of waterfalls, El Capitan hosts a pair of ephemeral, or temporary, flows. Ribbon Fall, one of the world's longest uninterrupted waterfalls, spills 1,612 feet (491 m) down the icon's west side in spring. Wispy Horsetail Fall, a photographer favorite, streams down El Capitan's east side and sometimes glows red and orange in February sunsets.

On the Valley floor beneath its namesake rock, El Capitan Meadow hums with life. A parking lane along the meadow is a great spot for observing El Capitan and Cathedral Rocks and Spires, as well as wildlife in the meadow.

Imagine scaling a big wall *and* trying to save a species at the same time. In the 1970s, Yosemite's peregrine numbers sank as the birds ingested DDT, a toxic insecticide. High on the cliffs, rock climbers removed DDT-laced eggs from falcon nests. They swapped in fake eggs for the parents to incubate, and then later returned to place healthy, lab-raised peregrine chicks in the nests. It worked, and today peregrines nest successfully on El Capitan and elsewhere.

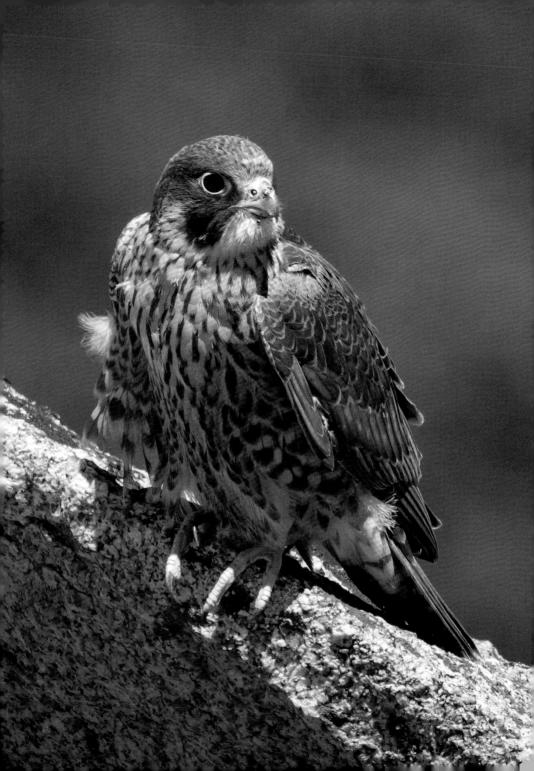

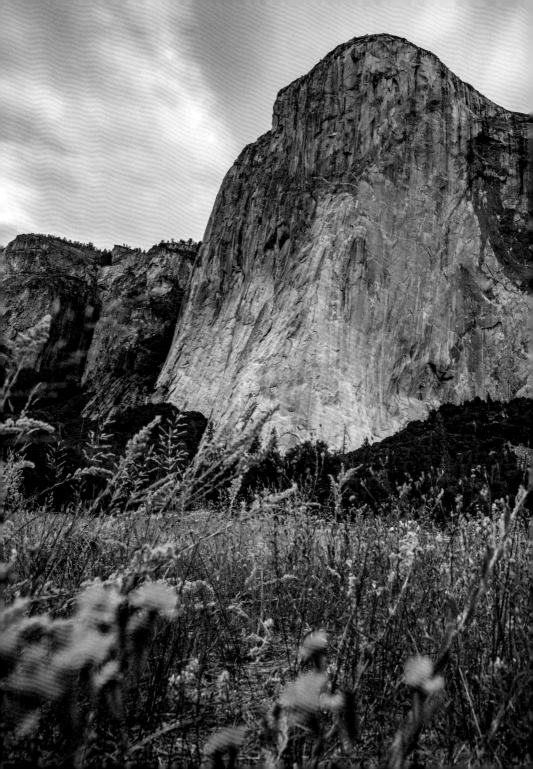

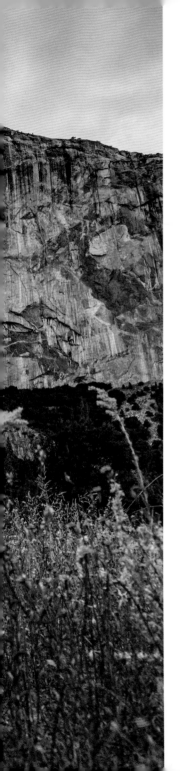

PLANTS AND ANIMALS

Like all Valley walls, El Capitan is part of the Yosemite Wilderness. (Wilderness designations are the highest level of public-lands protection in the United States and aim to keep select areas as natural and undeveloped as possible.) Many species make their homes below, on, and atop this safeguarded rock.

Our biodiversity tour starts at ground level. In El Capitan Meadow—about 4,000 feet (1,200 m) in elevation—western blue flags and penstemons bloom in spring, and mule deer graze on grasses. In autumn, black bears feast on black oak acorns. In winter, owls and coyotes hunt for small mammals in the subnivean zone, the insulated space below the snow.

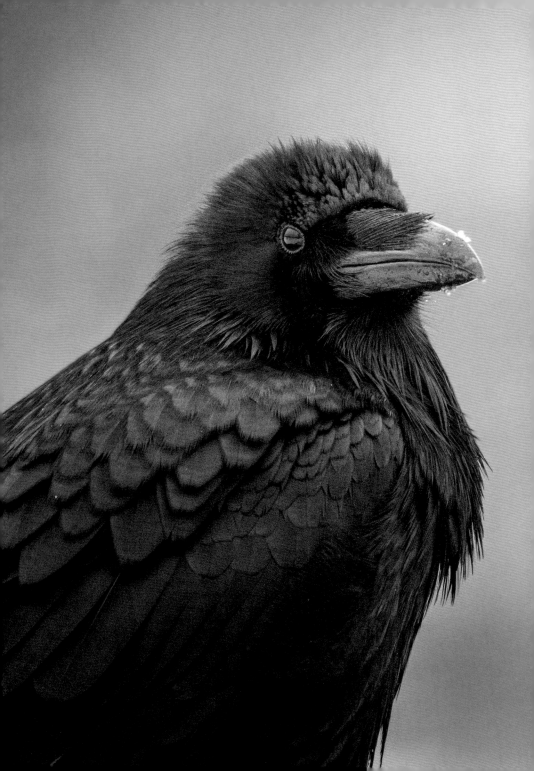

Closer to El Capitan's base, splashes of color come from red-barked manzanita, purple Sierra lupine, and magenta milkweed buds. Gilbert's skinks slink across the ground. Western gray squirrels gather seeds—and try to avoid becoming meals for bobcats and coyotes.

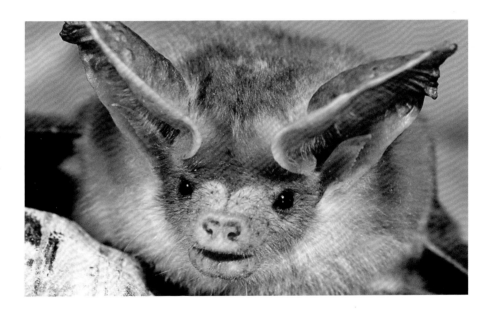

Now, let's head up the walls. A vertical rock face may not be your pick for a place to settle down—the lodging is dark and cramped or steep and sunbaked—but plenty of plants and animals spend time on El Capitan's cliffs. Ravens float through the thermals, calling and showing off to one another. Numerous bat species, including Mexican free-tailed and pallid bats, snooze in crevices during the day and swirl out as the sun sets.

Some birds also build nests up there. Violet-green swallows and white-throated swifts use grasses, twigs, bark, and feathers to make cup-shaped homes in crevices. Watch for them swooping around the walls, often in groups. They share the walls with one of their primary predators, the peregrine falcon. Peregrines create simple homes called *scrapes* by scratching shallow basins out of dirt or loose rock on cliff ledges.

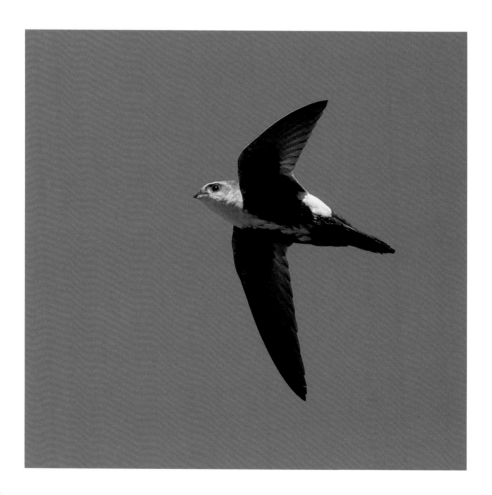

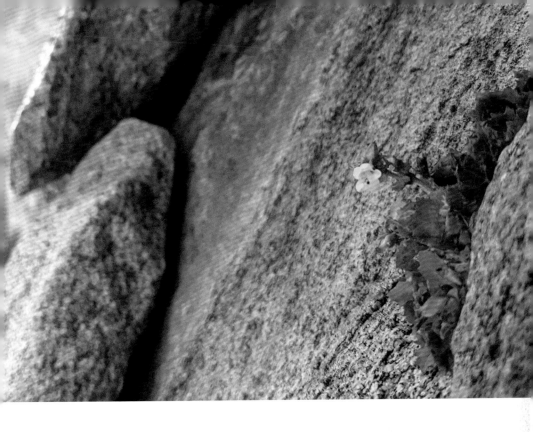

Wings are helpful for navigating El Capitan, but not essential. Sierran treefrogs, for example, have toe pads that work like suction cups to help them stick to the granite. Other talented climbers, like millipedes and mice, also traverse the walls.

Plants live on the walls, too. The colorful and intricate monkeyflower thrives in many different environments around Yosemite, including the cracks and crannies on El Capitan, where they have been unintentionally transported by climbers. They evolve so quickly that, within two generations, they can fully adapt to the moisture, temperature, and amount of sunlight in their new surroundings. Monkeyflower DNA is showing researchers how the natural world might recover from the trauma of climatic upset.

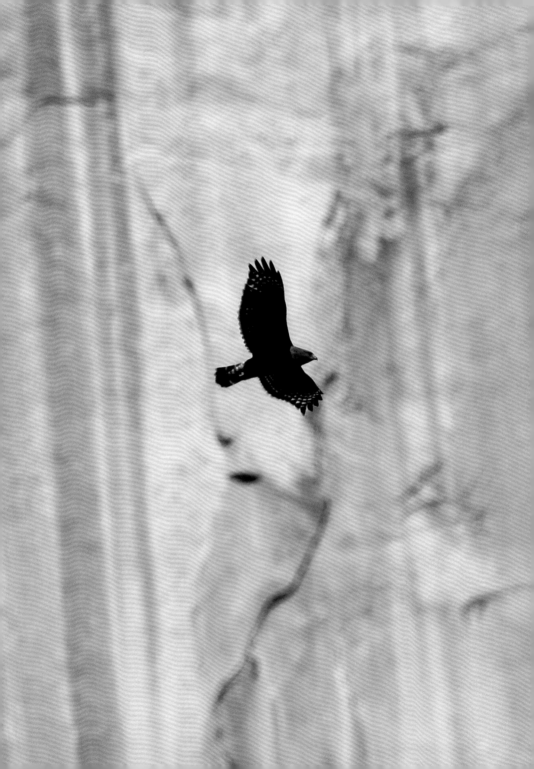

One 80-foot-tall (24 m) ponderosa pine is rooted on a sparsely vegetated shelf about 400 feet (122 m) up. (That's not the park's only cliffside tree; you may spy pines and live oaks on other Yosemite walls, the result of seeds landing on ledges or in fissures with adequate soil and water.)

Green, black, and orange patches on the walls are lichens, which form when certain kinds of fungi and algae grow together.

Our tour ends at the top. At 7,569 feet (2,307 m) above sea level, El Capitan's summit is in the upper montane zone. That's a vastly different ecological realm from the Valley floor, in the lower montane. Up here, scan the ground for Sierra stonecrop, a waxy, low-growing succulent. Western fence lizards and sagebrush lizards relax on sunny rocks. Red-tailed hawks soar past the walls, alighting on their high eyries. And mountain chickadees—identifiable by their white eyebrow stripes—belt out their name: *chick-a-dee-dee-dee.*

Human History

El Capitan is part of the ancestral home of the people now known as the Traditionally Associated Tribes of Yosemite National Park, and countless chapters of human history have unfolded here. In the nineteenth century, El Capitan was the backdrop to a violent interruption of traditional ways of life.

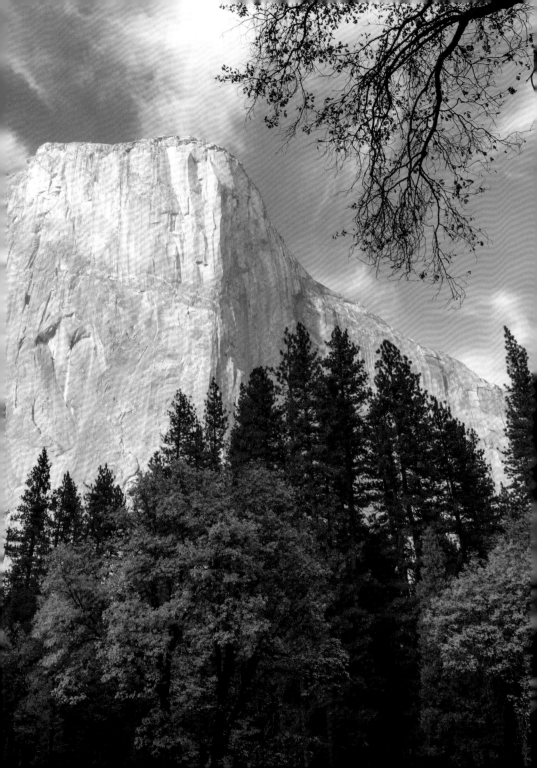

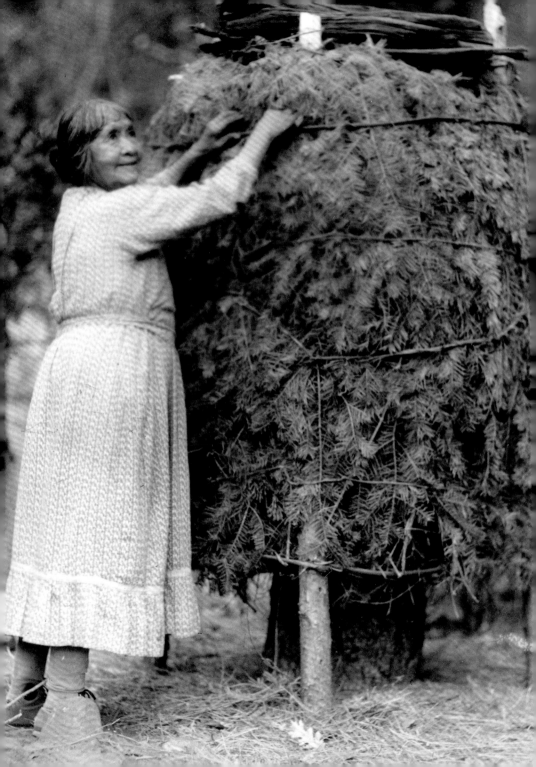

WITNESS TO HISTORY

For untold ages, people native to Yosemite lived in villages on the Valley floor. In the icon's shadow, they used fire to tend meadows, collected acorns for food, and gathered willow for woven baskets.

Then, in the mid-1800s, promises of gold and land drew miners and homesteaders to the Sierra Nevada. Disease and conflict spread. In 1851, the Mariposa Battalion, a state militia, raided the Valley. The soldiers chased and killed residents, burned homes and supplies, and forced survivors onto a reservation. Their brutal assault on Yosemite's longtime inhabitants was part of a statewide genocidal mission.

After the raids, word about Yosemite's beauty circulated thanks to artists and the press. An 1856 article described the "Giant's Tower"—El Capitan— as "an immense mountain of perpendicular granite" worthy of "wondering admiration." The 1864 Yosemite Grant act designated the Valley as state-protected public land, and in 1890, Yosemite became the United States' third national park. By the early 1900s, it was an explosively popular tourist destination, and hotels, stores, and roads mushroomed across the Valley floor. Visitors flooded into the park, eager to see El Capitan and other natural wonders.

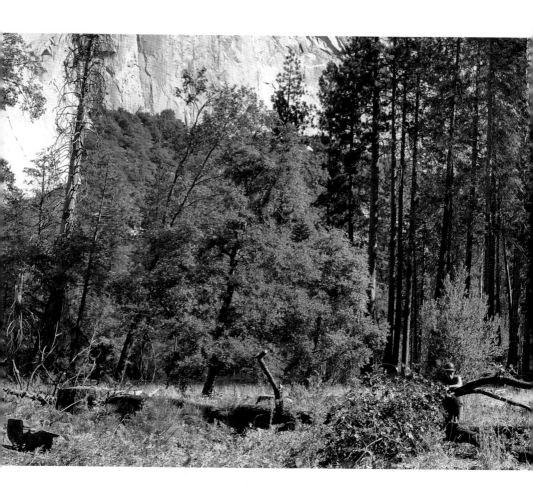

Some of the people native to Yosemite returned and lived among the growing non-Native population. They often worked for private employers and later for the National Park Service so they could stay in their ancestral home. After numerous attempts, NPS demolished the last Valley village in the 1960s.

Today, Yosemite's Traditionally Associated Tribes regularly consult on matters relating to the park, hold events within

its borders, and continue to use traditional practices and ecological knowledge passed down over generations. NPS works with tribal representatives on many projects in Yosemite, including reconstructing the Wahhoga village site between Yosemite Falls and El Capitan. For more on tribal history, practices, and ongoing stewardship in the Yosemite area, read *Voices of the People* (see Resources, starting on p. 62).

What makes a wall? In climbing terms, "big wall" typically refers to a route that would take most people more than a day to ascend. El Capitan's faces are home to multiple "big walls," including the famous Dawn Wall and North America Wall, both on the southeast face, and the Dihedral Wall and Salathé Wall, on the southwest face.

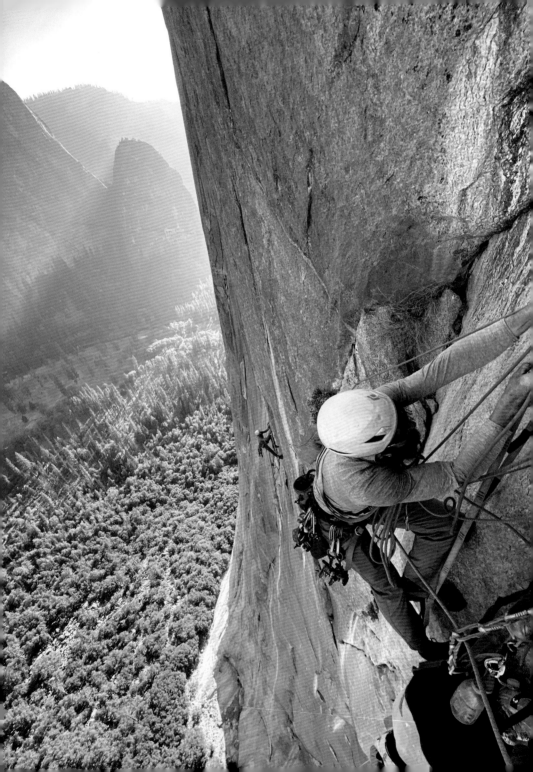

CLIMBING MAGNET

T oday, Yosemite is known as a
premier rock-climbing destination,
drawing climbers from around the
world. Documented Yosemite climbs
stretch back to the 1800s, but the park's
reputation as a hub for climbers—and for
climbing innovation—began in the 1930s.
In that era, Yosemite adventurers started
adopting European mountaineering
techniques. Climbers benefited from
surplus World War II supplies, such as
nylon ropes and iron wedges, or *pitons*.
They also created homemade gear
tailored to Yosemite's unique features.

Climbers went up the sheer faces of
Valley icons like Middle Cathedral Rock
and Half Dome, but not El Capitan.

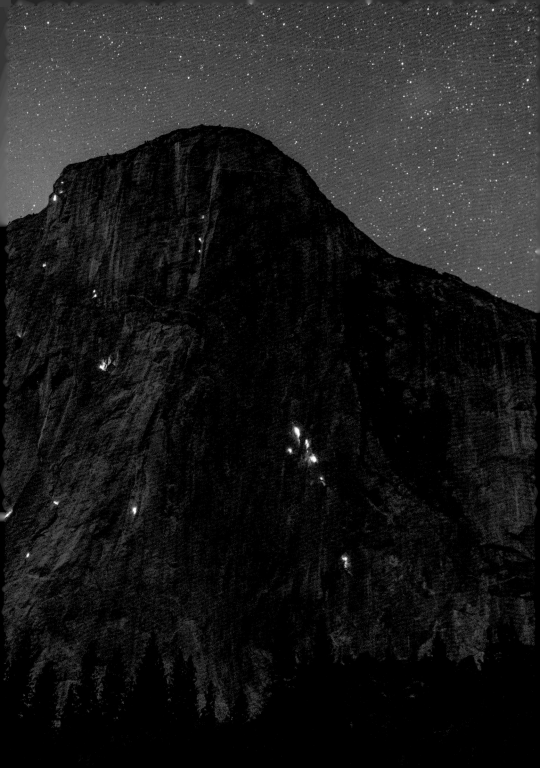

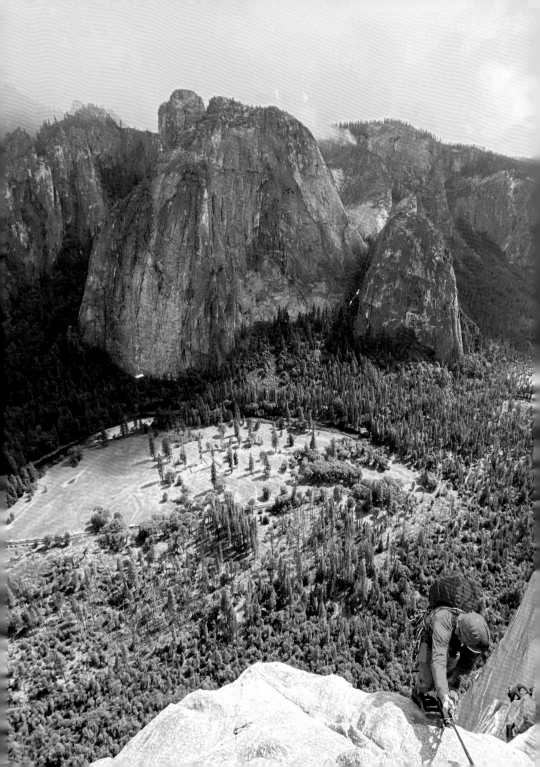

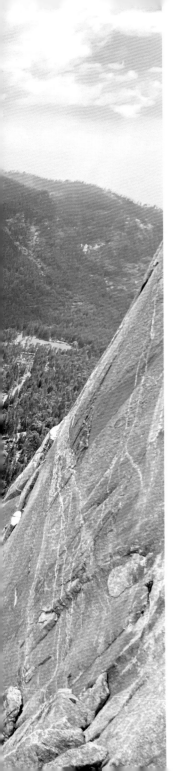

Then, in 1958, Warren Harding, George Whitmore, and Wayne Merry completed the first documented ascent of El Capitan, via The Nose. They worked in stages. They would climb up to attach ropes, retreat to the Valley floor, and then head up again, using the previously placed ropes to inch up the rock.

The journey took at least forty-five days of climbing, spread over eighteen months. Making it to the top required hundreds of bolts and pitons. The team even used wedges made from the metal legs of wood-burning stoves, since those were a good fit for the large cracks on the lower part of The Nose. (Today, climbers still refer to those cracks as "The Stovelegs.")

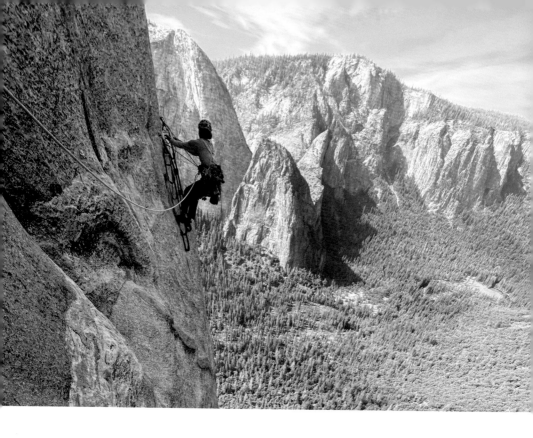

Let's take a quick detour into climbing lingo: In *aid climbing*, above, people use ropes and gear such as camming devices and stirrups, like you would a ladder, to help get up the wall. On a *free climb*, climbers use ropes and gear to protect themselves from falling, but not to help them ascend. A *rope solo climb* is done by a single climber and can involve both aid and free climbing techniques. And a *free solo* is a one-person climb with no protective gear—not even ropes.

Sixty years after that first ascent of The Nose, Alex Honnold scaled El Capitan via the Freerider route in under four hours with no equipment other than grippy shoes. That ascent is captured in the sweat-inducing 2018 documentary *Free Solo*.

El Capitan has hosted many other climbing firsts, among them: the first solo climb (Royal Robbins, Muir Wall, 1968); the first ascent by a woman (Beverly Johnson, The Nose, 1973); the first climb by a paraplegic athlete (Mark Wellman, the Shield, 1989); the first documented climb by an African American woman (Chelsea Griffie, Lurking Fear, 2001); the first ascent by an all-disabled team (Craig DeMartino, Pete Davis, and Jarem Frye, Zodiac, 2012); and the first free climb of the Dawn Wall, one of the world's most challenging routes thanks to its extra-smooth surface (Tommy Caldwell, below, and Kevin Jorgeson, 2015).

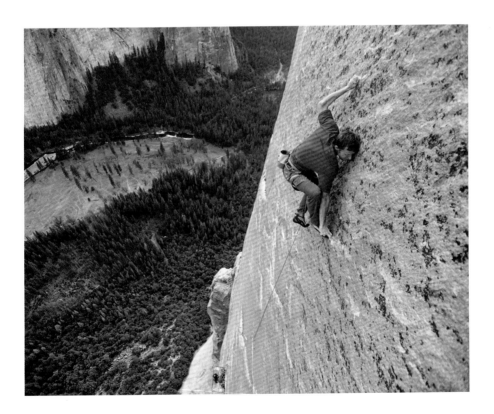

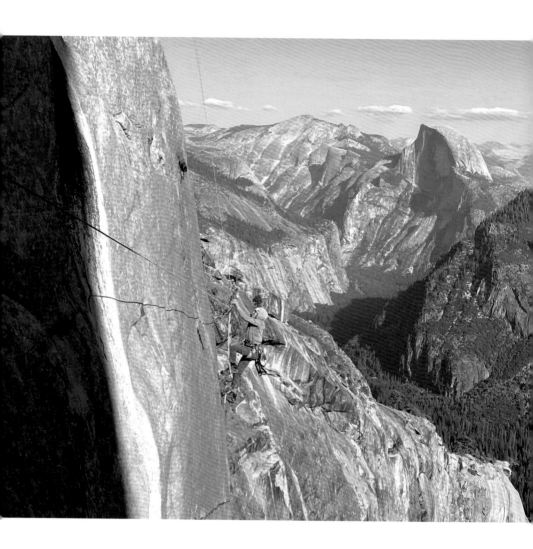

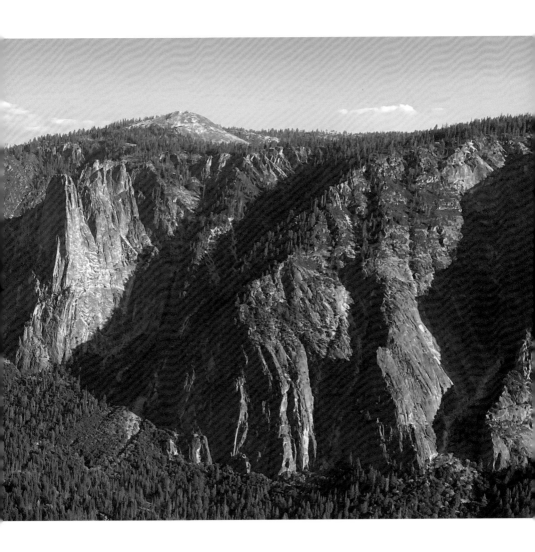

Depending on how they're counted, there are currently more than 250 routes on El Capitan. A few climbs make headlines. Hundreds don't. But each represents an enormous feat, often the culmination of years of training. And each is part of a long list of ascents that have pushed climbing's limits and spurred the evolution of techniques, tools, and ethics.

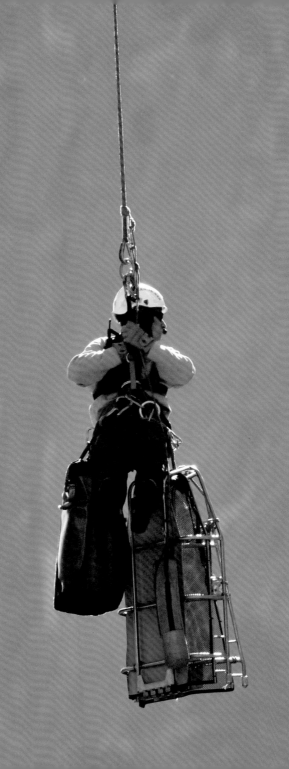

MODERN STEWARDSHIP

Not everybody heads to Yosemite's big walls for recreation. Rangers, researchers, and climbers go up El Capitan to study and steward the rock. Scientists examine bats, lichens, and rockfall scars. Volunteer "Yosemite Climber Stewards" clean up discarded gear. Search and rescue crews and climbing rangers help stranded or injured climbers, often using techniques invented in Yosemite.

El Capitan, which offers a look into an ancient magma chamber, also helps scientists learn about granite in Yosemite and beyond. Using laser data, photos, and rock samples, researchers have created a geologic map of the southeast face. The color-coded diagram shows a mosaic of eight kinds of granite and traces a timeline of underground rock formation. El Capitan's oldest granite cooled about 107 million years ago. Over the next few million years, younger granites formed as magma flowed into, or *intruded*, the older rock.

Since the mid-1900s, climbers have flocked to Yosemite's Camp 4, just off Northside Drive about 2 miles (3.2 km) east of The Nose. The campground earned its reputation as a hub of climbing culture as people (such as Royal Robbins, shown here in 1960) swapped tips and techniques, shared and sold equipment, practiced skills on massive boulders, and built a community of ambitious adventurers. Today, Camp 4 is on the National Register of Historic Places, thanks to Tom Frost, Dick Duane, and the American Alpine Club.

A lot of El Capitan science and caretaking takes place *on* the rock, but there's also plenty to do from the Valley floor. That includes geological research—you don't have to be on El Capitan to study it. Researchers stationed in El Capitan Meadow, for example, have used a thermal imaging camera to study *flakes* on The Nose. (Flakes are sections of rock that are peeling off. As El Capitan expands and erodes, some flakes can be the size of semi trucks, making them major rockfall hazards.) Using infrared images from the camera study, scientists have been able to see areas of cooler temperatures, which indicate where air is flowing behind flakes that have started to detach from the wall.

El Capitan Meadow is itself a hub for research, stewardship, and outreach. For instance, tribal members are working with NPS to restore the California black oak woodland and meadow ecosystems by using traditional techniques whenever possible to care for existing oaks. Heavy fuels are removed from the tree bases and then piled in preparation for prescribed burning. Tribal members also gather and plant high-quality acorns to seed future trees.

In and around the meadow, look for researchers using high-powered scopes to zoom in on peregrine nests built on rock faces. These observations inform temporary closures of climbing routes to help protect young falcons. You might also spot climbing rangers and stewards educating people on the ground. More on that coming up. . . .

Visiting El Capitan

El Capitan is most famous as a climbing destination, but that's not the only way to get to know it. Here are some other ways to experience this icon *without* traveling straight up.

A MULTIFACETED ICON

El Capitan features prominently in Valley-based views, including along the western part of the Valley Loop Trail. Compared to other famous Yosemite rocks, this icon has simple geometry: straight lines and flat faces. But, as you'll see, it has a habit of shape-shifting.

Stop at Tunnel View, on Wawona Road, to see El Capitan from a classic angle often captured in paintings and photos. Here, you'll see El Capitan's gently sloped forehead meet its near-vertical drop (The Nose). Is it a foreboding fortress, or a half-open door beckoning you into the Valley? It depends on your mood. Either way, El Capitan is breathtaking. At dusk, the southwest face sometimes gleams orange and pink. Winter sunsets are especially eye-catching.

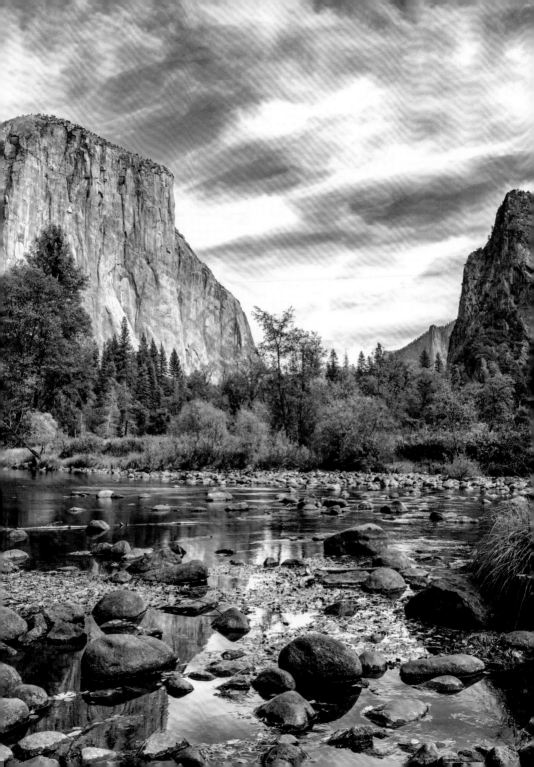

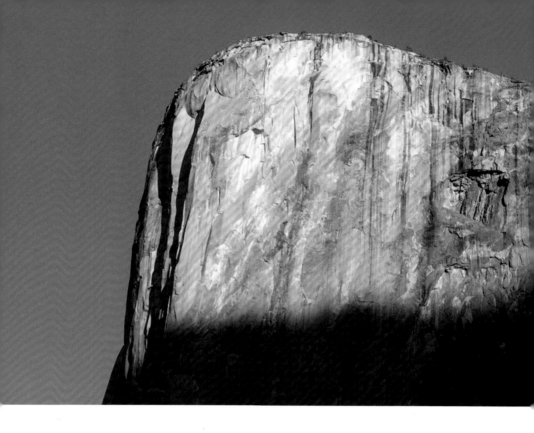

The Pohono Trail, a 13-mile (20.9 km) route that links Tunnel View and Glacier Point, offers plenty of chances to see El Capitan from the Valley's south rim. From Dewey Point, just west of Bridalveil Fall, you'll be almost right across from The Nose. Can you spot the North America Wall, the part of El Capitan's southeast face where dark granite (diorite) traces an outline that resembles the continent?

For another scenic stop on the south rim, try Sentinel Dome, whose summit reaches to 8,127 feet (2,477 m) above sea level. Here, you can use binoculars or a camera to zoom in on hardy shrubs and pines braving El Capitan's exposed summit. From the dome, you'll be looking toward the Dawn Wall, a section of granite (and famous climbing route) on El Capitan's upper southeast face.

If you're curious about the Dawn Wall's name, wake up early to watch morning light illuminate the granite. You'll find especially striking sunrise views from the south shore of the Merced River on the Valley floor, plus bonus views of El Capitan reflected in the water.

As you might expect, any of the destinations with "El Capitan" in the name are opportunities for good views of the icon. From El Capitan Bridge, which crosses the Merced on El Capitan Drive, peer up at The Nose framed by pines. At El Capitan Picnic Area, off Northside Drive about a mile east of the bridge, enjoy lunch with a side of views of Cathedral Rocks—and, of course, of El Capitan. These stops are easy to reach by bike, foot, car, or seasonal shuttle, and both are wheelchair accessible.

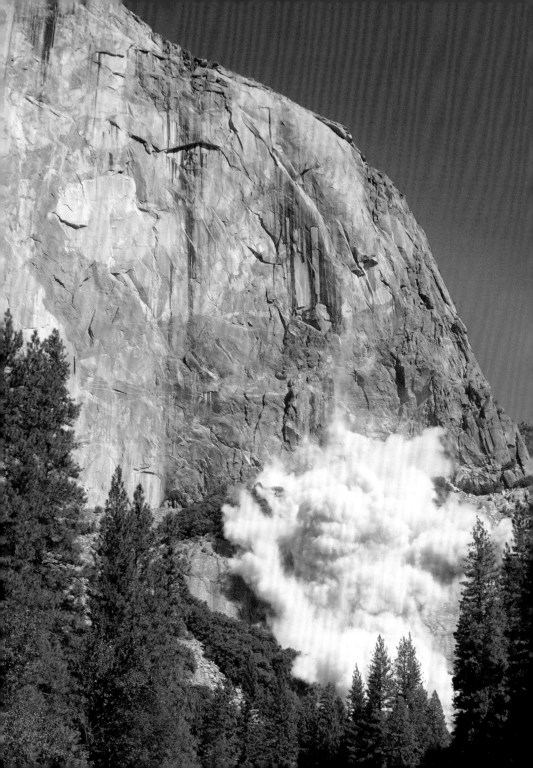

TO THE ROCK

We've covered the options for catching views of El Capitan, but how about the view from El Capitan? Those up for a long hike can reach the top without ropes and harnesses. From the Valley floor, take the Yosemite Falls Trail to the rim and then follow the route west for 7.7 miles (12.4 km) one way to El Capitan's summit. You'll get superb views in exchange for a full day of intense physical activity.

For even more mileage and scenery, take the north rim route from Porcupine Creek to Tamarack Creek. The 23-mile (37 km) point-to-point journey stops by North Dome, Yosemite Point, Yosemite Falls, Eagle Peak, and El Capitan. If you plan to camp along the way, get a wilderness permit.

It is risky and not recommended to linger right below this icon, or any of Yosemite's big walls. Rockfalls (such as the one shown from 2010) and rockslides are a regular and natural occurrence in the park. Always heed warning signs and trail closures, and if you do end up near the walls, stay alert. Move away quickly if you hear cracking or popping sounds, or if you notice signs of recent rockfalls, such as boulder tracks in the dirt, a trail of rocks that look unlike the others nearby, damaged vegetation, or fresh cliff scars, which will look lighter than the surrounding granite. Report any rockfall sightings to NPS.

However you experience El Capitan, remember to stay on trails, store food and scented items in a bear locker or canister to protect bears and other wildlife, and pack out all litter and leftovers.

AN INSIDER'S VIEW

You can experience El Capitan from many parts of Yosemite, but one of the best ways to get a sense of the icon is to stay in one place—El Capitan Meadow—and take part in the Ask a Climber program. For a few months each year, rangers and volunteers set up telescopes in the meadow and talk to visitors about the vertical wilderness. As you watch climbers through a lens, take a cue from the program's name: Ask questions! How do people train to climb Yosemite's big walls? What causes rockfalls? Why do some birds and bats opt to live on the cliffs?

To learn even more about El Capitan and rock climbing, visit the climbing exhibit in Yosemite Village. There, you can see gear from different eras, feel a model rock wall, and explore climbing milestones.

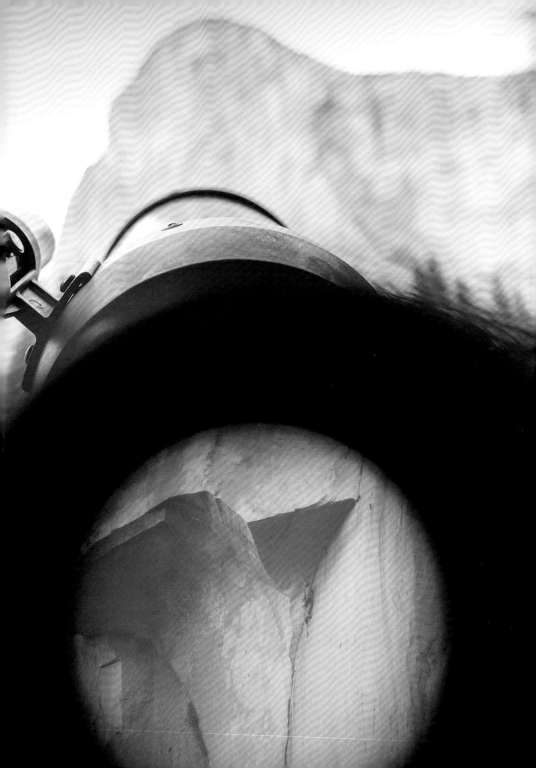

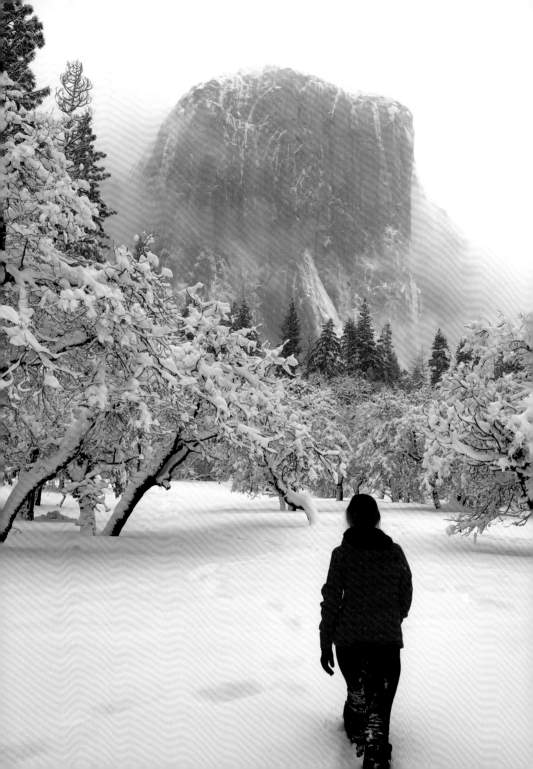

SEASONAL SHIFTS

El Capitan is reliably impressive in every season. On stormy spring days, watch wisps of cloud gather around the icon's sharp edges. In autumn, pause at Valley View, a riverside stop off Northside Drive, and look for golden-leaved black oaks and cottonwoods shimmering against muted walls.

If there's enough water to feed the flow, Horsetail Fall is usually visible from December through April and puts on its famous fiery show in February (check the park website in case reservations are needed). Ribbon Fall typically flows March through June. For a hike to the top, aim for early summer through early autumn, when routes are more likely to be snow-free. (That said, trails to the top are open year-round. If you're planning a winter hike, be sure you have the skills and supplies to stay safe.)

To catch Ask a Climber, plan on a non-winter visit; schedules are available online. If you're keen to see climbers in action, spring and fall are the most popular seasons for ascents. During the day, look for tiny figures inching up the walls. After sunset, climbers' headlamps twinkle against the dark cliffs.

El Capitan is not just a block of rock. It's a captivating storyteller, teaching us about ancient magma and ice, conflict and development, astonishing athletic feats, and the tenacity of life in the vertical wild.

Yosemite's icons are far more than immense, stunning natural features. They also tell us about the park's past and present, and they prompt questions about its future. How can you help protect this iconic place for future generations?

RESOURCES

Check out these resources for more in-depth information on Yosemite and El Capitan, including natural and human history, things to see and do, places to stay, and ways to help protect the park.

Yosemite National Park: The National Park Service manages Yosemite National Park and is your best resource for the most comprehensive and up-to-date information about visiting the park, current conditions, natural resources, history, safety, and more.

WEBSITE: nps.gov/yose. For **trip-planning tips,** go to nps.gov/yose/planyourvisit. **CALL:** 209.372.0200 (general questions). For questions related to trip-planning and permits for the Yosemite Wilderness, including climbing permits for El Capitan, call 209.372.0826 (in service March through September).

Yosemite Conservancy: As Yosemite National Park's cooperating association and philanthropic partner, the Conservancy funds important work in the park and offers a variety of visitor resources and activities, including art classes, guided Outdoor Adventures and Custom Adventures, volunteer programs, and bookstores.

WEBSITE: yosemite.org. To see the Conservancy's four **Yosemite webcams,** including one aimed at El Capitan, visit yosemite.org/webcams. **CALL:** 415.434.1782

Yosemite Hospitality: A subsidiary of Aramark, Yosemite Hospitality, LLC, is an official concessioner of Yosemite National Park, and it operates hotels, restaurants, stores, visitor programs, and more.

WEBSITE: travelyosemite.com **CALL:** 888.413.8869 (U.S.) or 602.278.8888 (International)

The Ansel Adams Gallery: Located in Yosemite Village, the gallery celebrates Ansel Adams's work and legacy, showcases other photographers who capture the American West, and offers photography workshops.

WEBSITE: anseladams.com **CALL:** 209.372.4413

Voices of the People: This book by the Traditionally Associated Tribes of Yosemite National Park (Bishop Paiute Tribe, Bridgeport Indian Colony, Mono Lake Kootzaduka'a Tribe, North Fork Rancheria of Mono Indians of California, Picayune Rancheria of the Chukchansi Indians, Southern Sierra Miwuk Nation, Tuolumne Band of Me-Wuk Indians) offers detailed information and insights from

the people native to the Yosemite area. Published by the National Park Service in 2019, *Voices of the People* is available from Yosemite Conservancy and digitally from most e-book vendors.

Yosemite Climbing Association: The Association runs a gallery and museum in Mariposa dedicated to Yosemite's climbing history, coordinates the Yosemite Facelift cleanup event, and sponsors the Yosemite Climbing Information website, which features regular updates from the park's climbing rangers. (nps.gov/yose/learn/photosmultimedia/ynn.htm).

WEBSITE: yosemiteclimbing.org and climbingyosemite.com

Yosemite Nature Notes: This series of short documentaries about Yosemite dives into the park's geology, ecology, human stories, and more. For El Capitan–related content, see Episode 10 ("Rock Fall") and Episode 20 ("Granite"). Find all *Yosemite Nature Notes* episodes on the Yosemite National Park website (nps.gov/yose/learn/photosmultimedia/ynn.htm).

PHOTO CREDITS

1: El Capitan under stars. Photo by Nicolas Moscarda on Unsplash.
2, 3: El Capitan, Half Dome and Clouds Rest in winter. Photo by Nick Fedrick.
4, 5: Half Dome, Giant Staircase, and Yosemite High Country. Photo by Charles Chu on Unsplash.
6: El Capitan. Painting by Thomas Hill, 1871. L. Prang & Co., Boston. Library of Congress Prints and Photographs Division: LCCN 94508710.
8, 9: Autumn sunrise at Tunnel View. Photo by David E. Grimes.
10: Pure Serenity: El Capitan and the Merced River. Photo by Trish McCubbin.
12, 13: The colors of El Capitan. Photo by Tom Evans.
14, 15: Glacial polish. Photo by Greg Coit.
16: El Capitan evening glow. Photo by Sam Isaac Photography.
18, 19: Horsetail Fall. Photo by Cedric Letsch on Unsplash.
21: Juvenile peregrine falcon at home in Yosemite. Photo by James McGrew.
22, 23: Wildflowers in El Capitan Meadow. Photo by Dakota Snider.
24: Raven. Photo by Jeremy Hynes on Unsplash.
25: Pallid bat. Courtesy of NPS.
26: White-throated swift in flight. Photo by Agami Photo Agency/Shutterstock.
27: Monkeyflower in a crack on El Capitan. Photo by Diana Tataru.
28, 29: Red-tailed hawk flying past El Capitan. Photo by Tom Evans.
30, 31: El Capitan and black oaks. Photo by Robb Hirsch.
32: Tabuce "Maggie" Howard with chuckah, or acorn granary, 1935. Courtesy of the Yosemite National Park Archives, Museum and Library, RL_12791.
34, 35: Chris Pisano and son Logan use hand saws to reduce fuels in the El Capitan grove. Photo by Sandra Vasquez.

37: Climbers on Mescalito route. Photo by Billy Unjea on Unsplash.

38, 39: Climbers' headlamps create a constellation of lights on El Capitan. Photo by Kristal Leonard.

40, 41: Climbers on The Nose. Photo by Billy Unjea on Unsplash.

42: Aid climbing on Lurking Fear. Photo by Zack Little.

43: Tommy Caldwell on pitch 19, during the historic nineteen-day free climb of the Dawn Wall, 2015. Photo by Corey Rich/Cavan Images.

44, 45: Climber on Mescalito route. Photo by Billy Unjea on Unsplash.

46: Yosemite search and rescue high-altitude training. Photo by Tom Evans.

49: Royal Robbins sips tea while sorting hardware in Camp 4 in preparation for the second (and first continuous) ascent of The Nose in 1960. Photo by Tom Frost, courtesy of the North American Climbing History Archives (NACHA).

50: Revealing a black oak seedling surrounded by invasive cheat grass. Courtesy of NPS.

53: Valley View. Photo by Rakshith Hatwar on Unsplash.

54, 55: El Capitan at first light. Photo by Halie West on Unsplash.

56: El Capitan rockfall, October 11, 2010. Photo by Tom Evans.

58, 59: Spotting an El Capitan climber during an Ask a Climber program. Photo by Vikki Glinskii, The RV Project.

60: El Capitan in fresh snow. Photo by Diana D'Andrea, @hikingd_adventures.

Back cover: El Capitan. Photo by Casey Horner on Unsplash.

YOSEMITE
CONSERVANCY.

yosemite.org

Yosemite Conservancy inspires people to support projects and programs that preserve Yosemite and enrich the visitor experience for all.

Text by Gretchen Roecker
Book design by Eric Ball Design
Cover art by Shawn Ball

ISBN 978-1-951179-27-4

Printed in China by Reliance Printing

1 2 3 4 5 6 – 27 26 25 24 23

MIX
Paper from
responsible sources
FSC® C102842
www.fsc.org